If you have a home computer with Internet access you may:

- request an item to be placed on hold.
- renew an item that is not overdue or on hold.
- view titles and due dates checked out on your card.
- view and/or pay your outstanding fines online ($1 & over).

To view your patron record from your home computer click on
Patchogue-Medford Library's homepage: www.pmlib.org

D1401393

ANIMAL SHELTER PORTRAITS

Animal Shelter Portraits
by Mark Ross

This edition © Mark Batty Publisher, 2012

Typeset in Knockout

Library of Congress Control #2011924561

ISBN: 978-1-9356133-4-3

10 9 8 7 6 5 4 3 2 1 First edition

Printed and bound in the United States of America

Mark Batty Publisher
68 Jay Street, Suite 410
Brooklyn, NY 11201
www.markbattypublisher.com

Distributed outside North America by:
Thames & Hudson Ltd
181A High Holborn
London WC1V 7QX
United Kingdom
Tel: 00 44 20 7845 5000
Fax: 00 44 20 7845 5055
www.thameshudson.co.uk

ANIMAL SHELTER PORTRAITS

PHOTOGRAPHS BY MARK ROSS

MARK BATTY PUBLISHER ■ NEW YORK CITY

INTRODUCTION

BY MARK ROSS

In April 2009, I decided it was the time in my life to do something of value, and I wanted to do it with others in mind. I have always loved and admired companion animals, so it seemed logical to volunteer at an animal shelter. I could take photographs of them, too. Why not? After the required orientation, I was mustered into a volunteer program.

After the first six months or so, as my collection of animal shelter photographs grew, I wanted to share them with others, and Facebook was the obvious avenue. I began posting a regular stream of cats and dogs, including whatever notes about them that were available. Right off the bat, things began to improve! The foster/adoption/rescue rate picked up and people told me that my photographs were the very reason they took notice of an animal and came forward to save it.

From the onset of this project, I wanted to show these animals in a different light, portraying each and every one in the most emotionally provocative manner I could, so that the observer had to stop and look, and perhaps then feel something for that animal, connect with it. That was my hook. Turns out, it worked. Once seen on Facebook and shared by many animal lovers, the animals I had photographed flew off the shelf, so to speak. People fell in love with them and came through to save them, in any way they could. I can't express how gratifying it has been.

I hope this book furthers my mission to not only save animals, but raise awareness about the realities of kill shelters. To see up close and personal what these precious creatures look like and evoke what they must feel like as they await their uncertain fates. All these wonderful companion animals share one thing in common and that is that they have been given up and have no place to go. The great majority of these sad, lonely, suffering, incarcerated souls will never be seen by the general public and because of that many, if not most, will die. The public needs to understand that they are the only chance that these animals have for a pardon from a sentence handed down to them by the carelessness of others.

I hope these photographs and testimonials from other volunteers open some eyes and hearts, educate, and awaken the public to this terrible dilemma. These abandoned animals deserve to live out their lives in loving homes.

ANIMAL SHELTER PORTRAITS

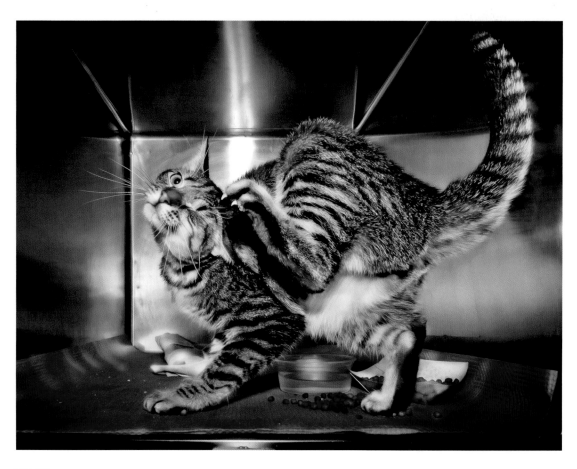

TIGGER

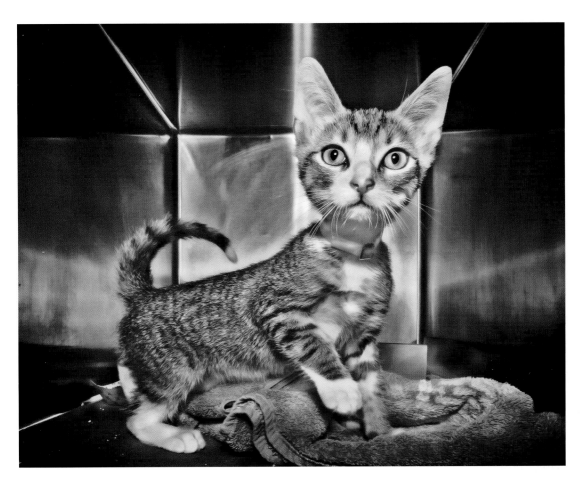

SANDY

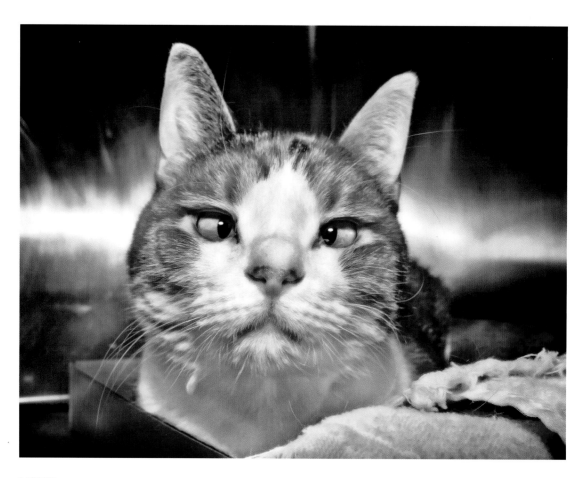

LABANA

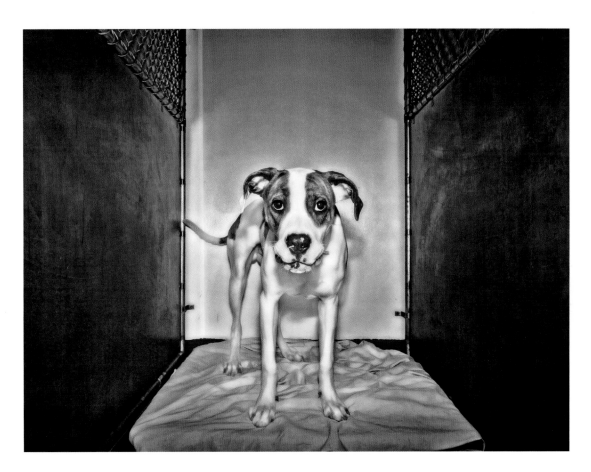

RICHIE

PHOTOGRAPHS BY MARK ROSS 11

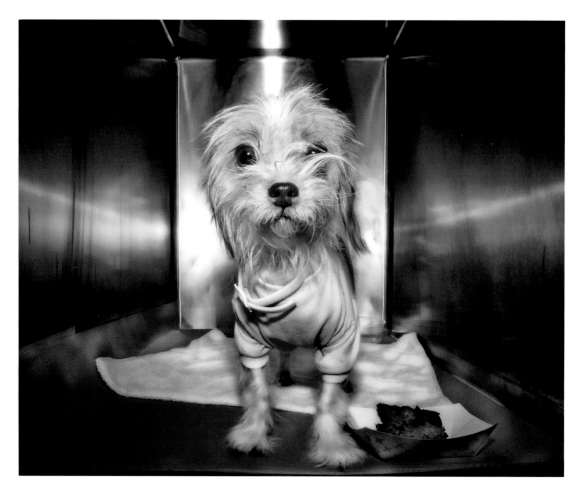

PRINCESS

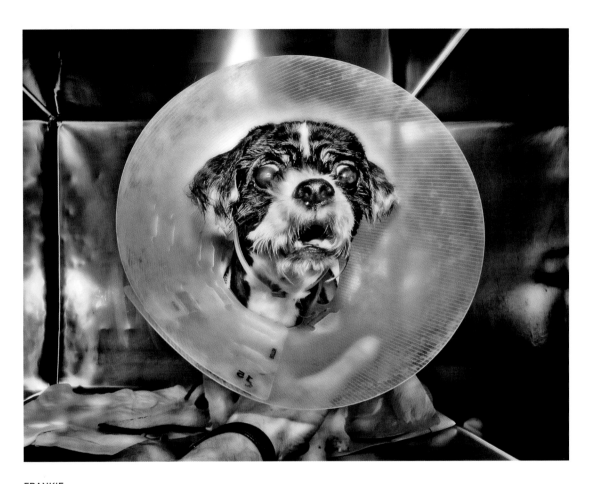

FRANKIE

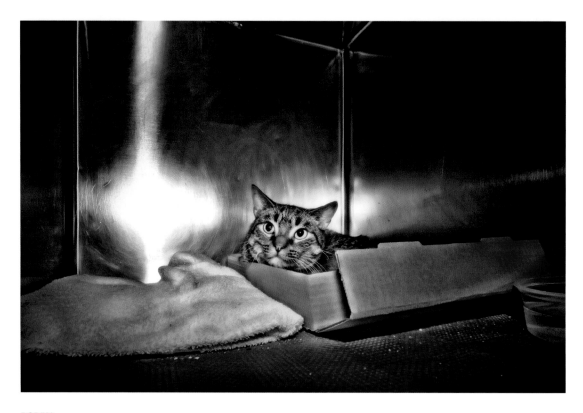

BOBBY

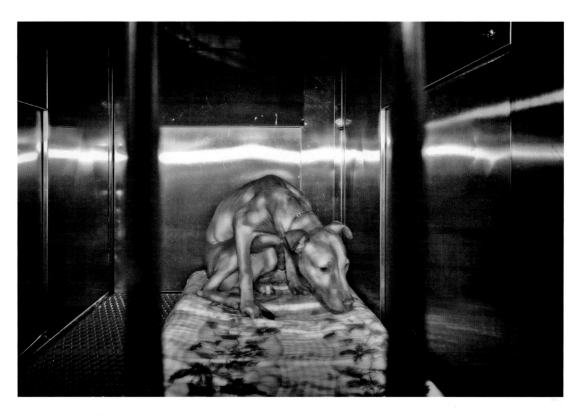

(NAME UNKNOWN)

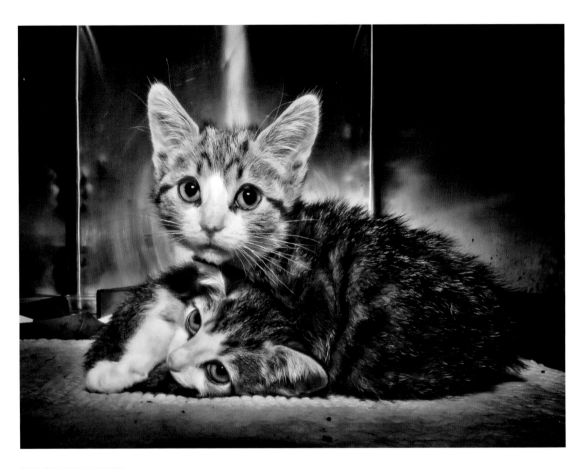

WILLOW & MR. HAPPY

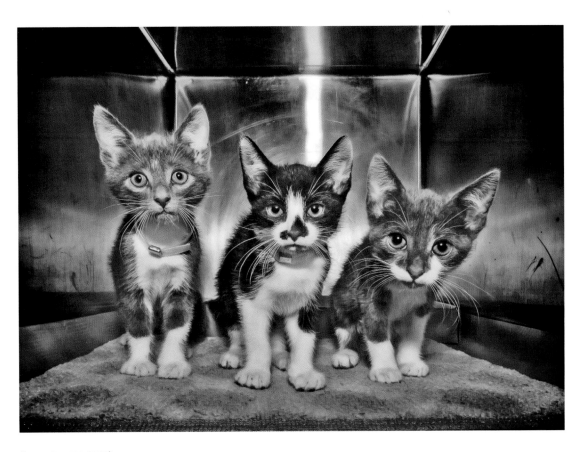

(NAMES UNKNOWN)

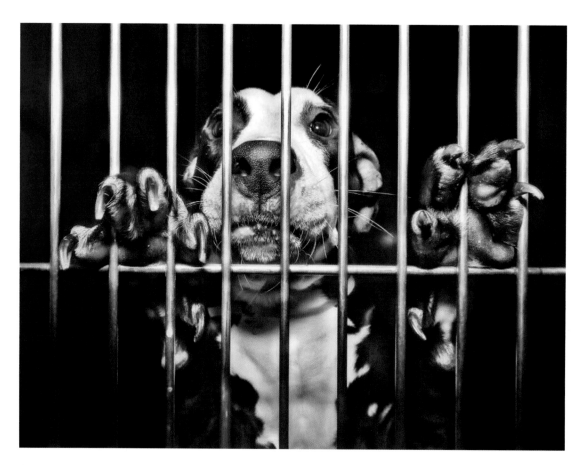

(NAME UNKNOWN)

"If you think it's hard being on the outside of a cage looking
in, can you imagine what it's like being the one inside look-
ing out?"
—From a volunteer's letter.

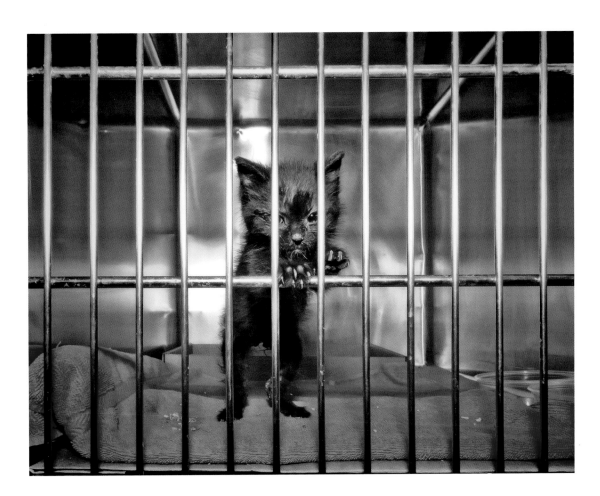

BRYANT

All black male, five weeks old, domestic shorthair, stray
found on street.

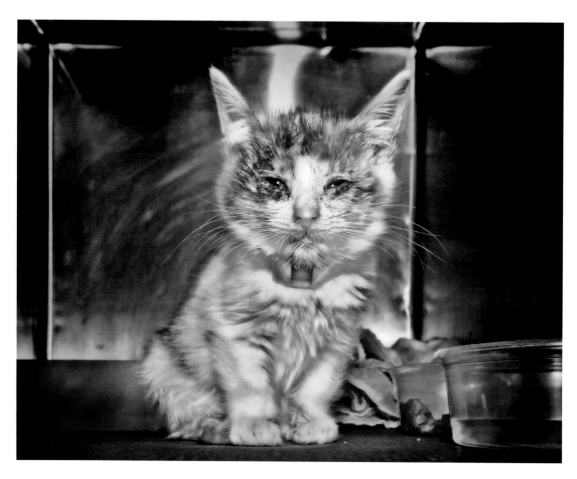

ROSEY

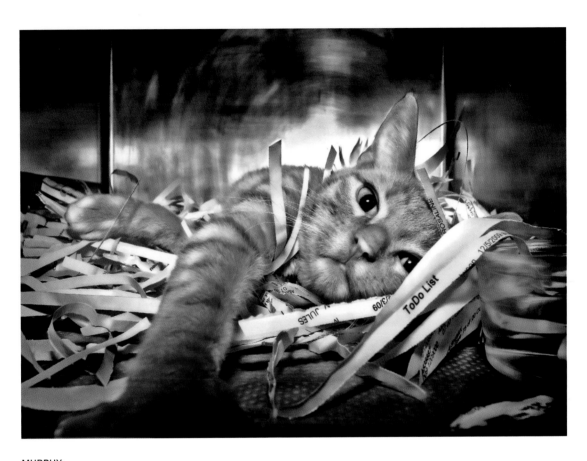

MURPHY

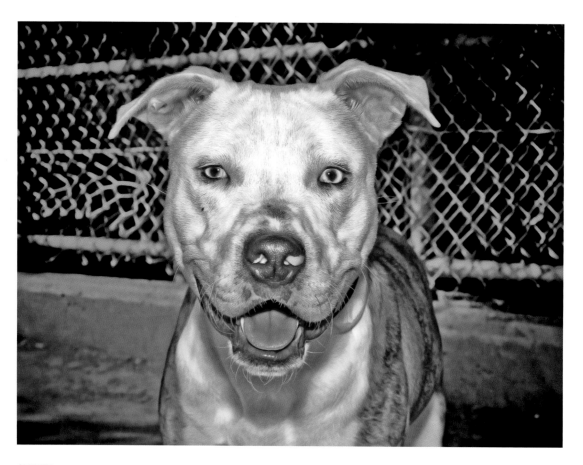

GENKIN

Two-year-old male, American Staffordshire mix, abandoned
in front of a building, inadequate facility.

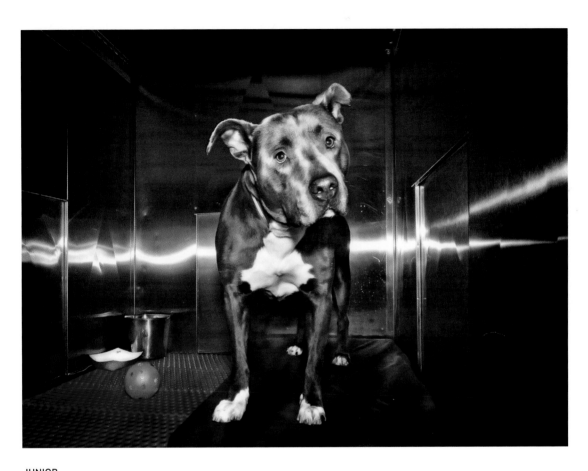

JUNIOR

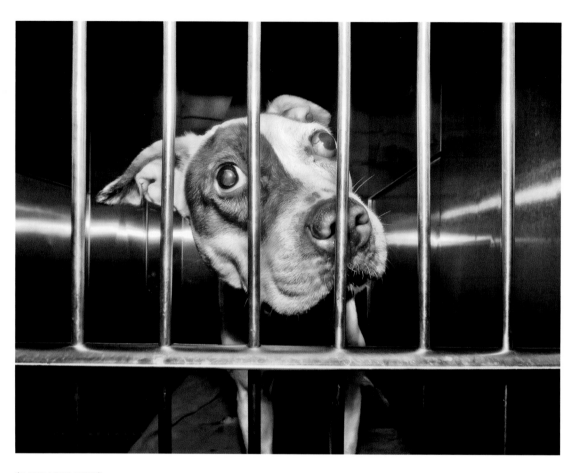

(NAME UNKNOWN)

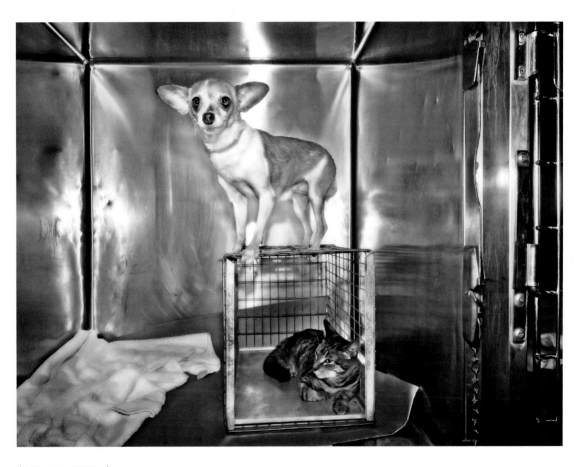

(NAMES UNKNOWN)

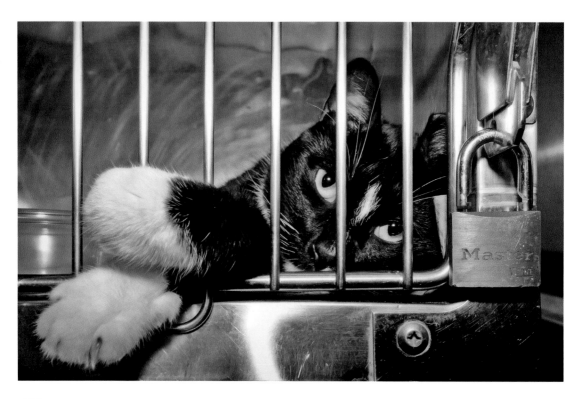

RYAN

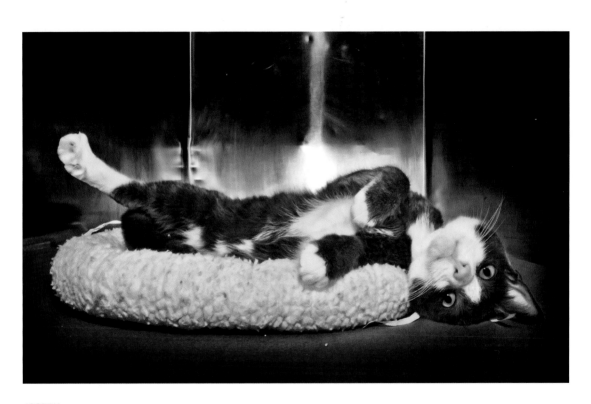

JOSEPH

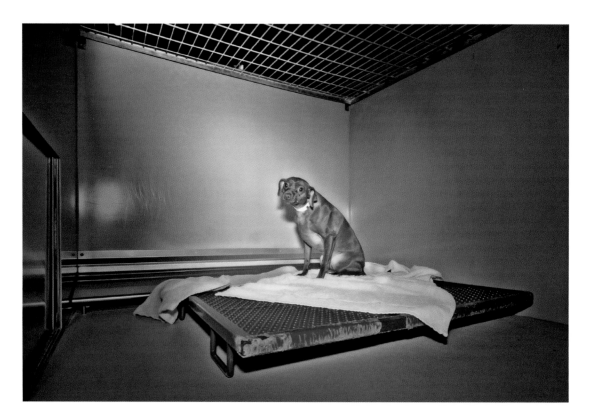

(NAME UNKNOWN)

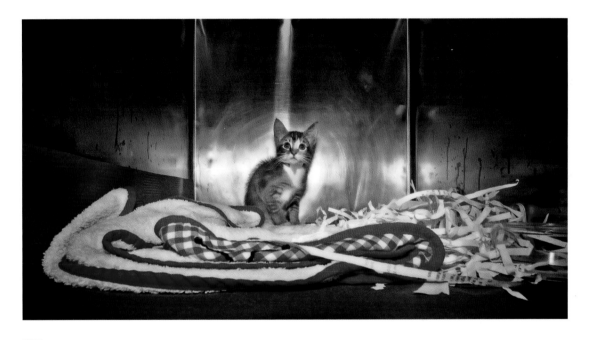

GIGI

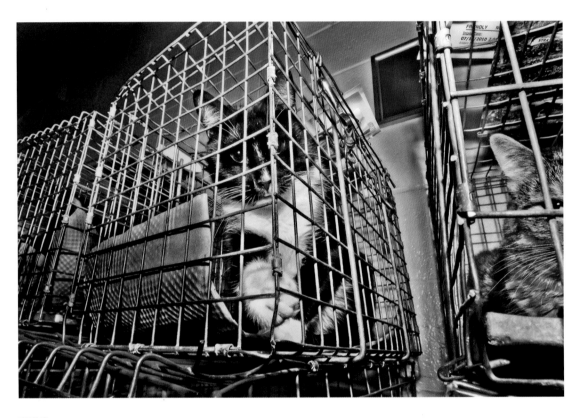

BRIAN

Brian is a one-and-a-half year-old neutered male whose owner died and left him all alone in his apartment, so he was rounded up by the cat police and brought into the kill shelter. It was there that we met as I was on my weekly rounds as a volunteer photographer for the shelter, taking photos of some of the most recent intakes. I took one look at Brian and fell in love with him immediately. He's very cute, a little quirky (he's got a little hop to his step), and wonderfully friendly. He loves people and he loves other cats. I suspect he also loves, or at least likes, dogs too! He's healthy, has all his shots and tests, and is micro chipped.

A few days later, a friend asked me to help her pick up a cat from the shelter that morning. Afterwards, I made my way up to the adoption ward to say hello to Brian. I had been thinking about him. Parked in the hallway just outside the ward, were stacks of tomahawks (transport cages) packed high on a dolly waiting to be brought downstairs to medical where they were to be killed. There, at the top of the heap, was Brian. I remember yelling. "What?" No, not my Brian! He had gotten himself a slight cold, an upper respiratory infection as they call it, and like many, if not all the others on that dolly, was going to be killed rather than cured of a simple cold. That's the way it is in a kill shelter. It's what you see every single day at these places. "Well what did you do, Mark?" you might be asking yourself. I made my way back down those same stairs and into the main office pleading with them to please pull Brian off the so-called Euthanasia List, that I wanted to save him! "Please pull him right away; I'll adopt him right now!" And that's what I did. How else would I have found out that Brian the cat likes salsa!?

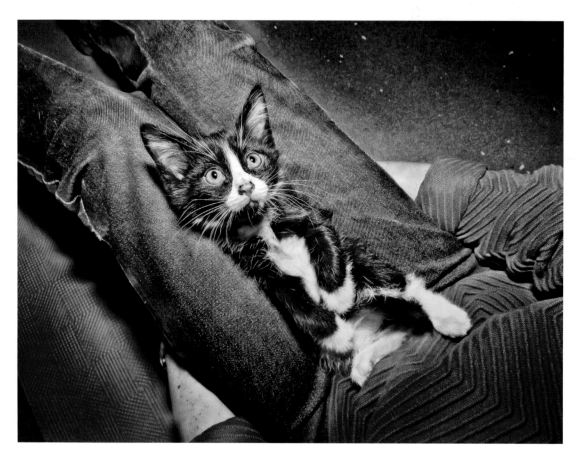

GLEN

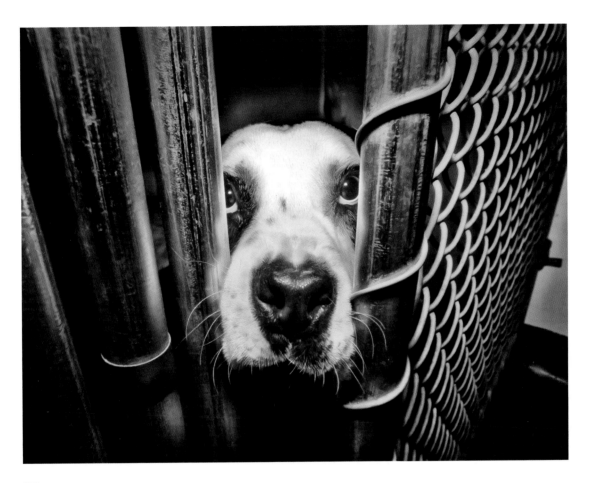

EVA

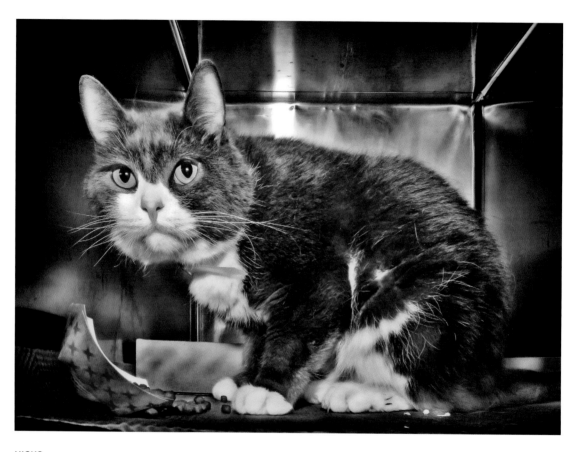

NICKO

What's he like? He's a strong pusher who is friendly and
very physical, in a good way! He made me laugh just trying
to keep him in his kennel while I photographed him with the
door open. He's serious but he's adorable so his serious-
ness makes you like him all the more.

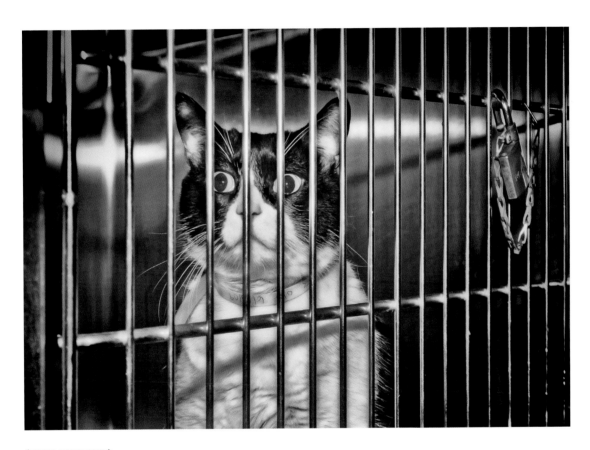

(NAME UNKNOWN)

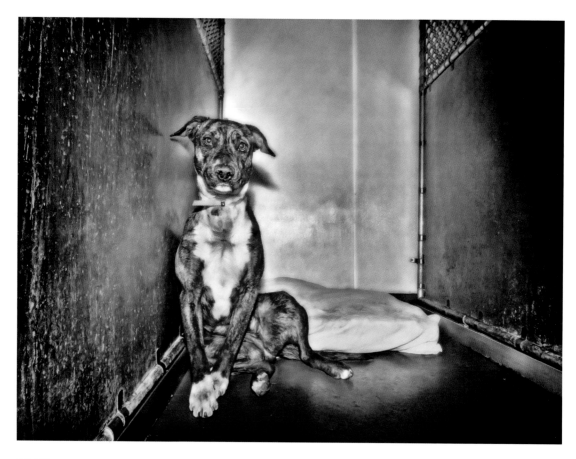

COSMO

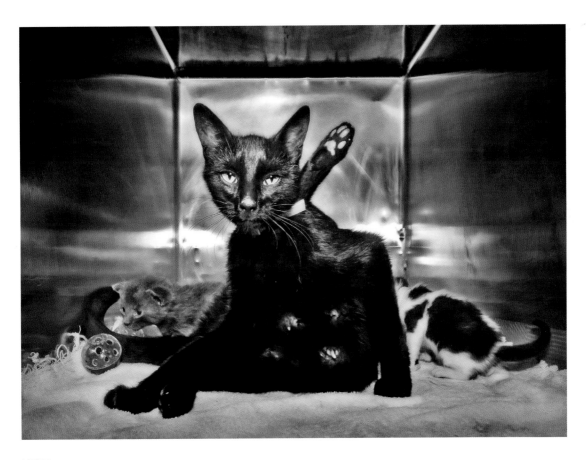

MAMA

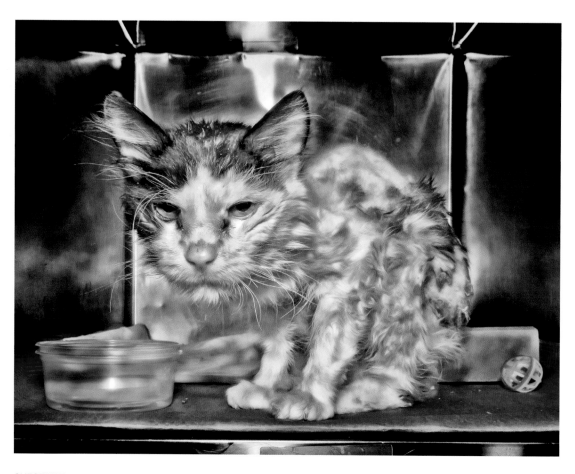

CHESTNUT

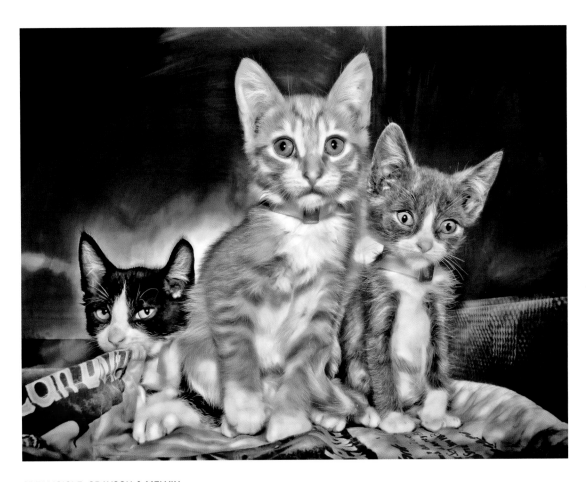

CREAMSICLE, GRAYSON & MELVIN

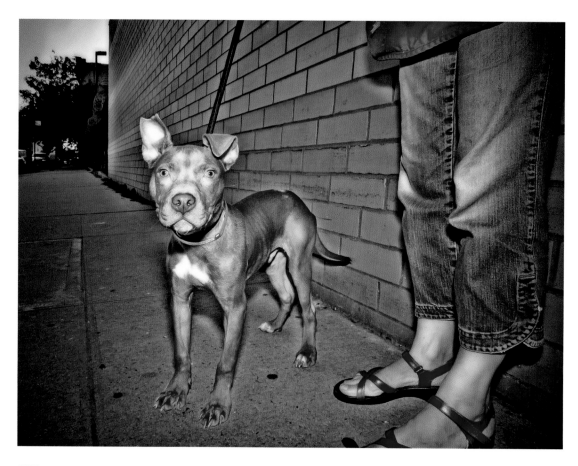

SAM

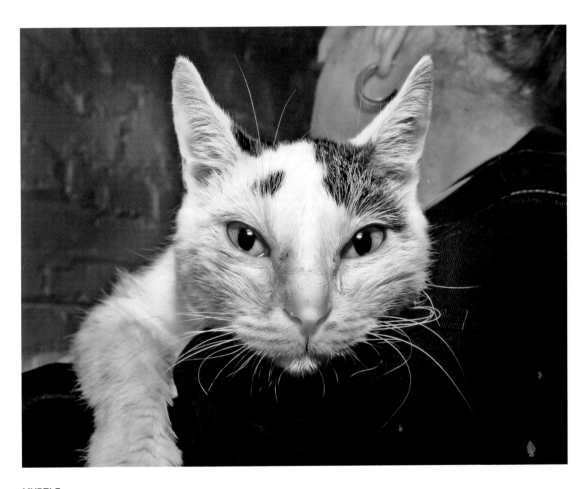

MYRTLE

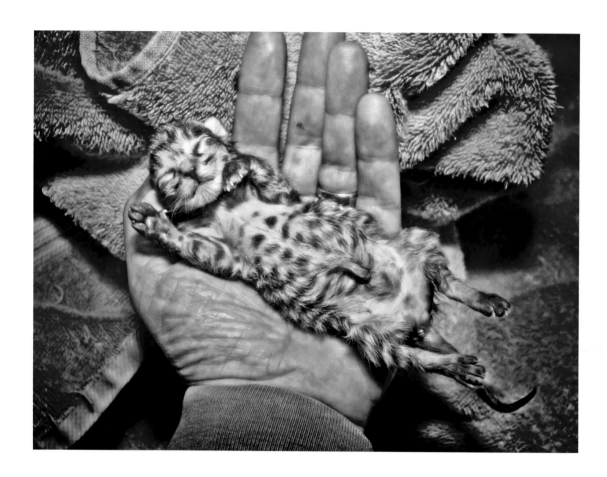

A mother cat was brought in with four extremely cold newborns, having been found outdoors on a cold Sunday afternoon. Shelter volunteers set up a heat lamp, got some plush towels, and sat down on the floor of the maternity ward trying to revive each of them. Through rubbing their tender little bodies with warm towels heated by the lamp and breathing on them, even placing them under their shirts against their own warm bodies, one by one each came around, all but one that is. Within maybe twenty minutes, three of the original foursome had made the transition from near-death to regaining their life. I watched in amazement all the while recording this remarkable event!

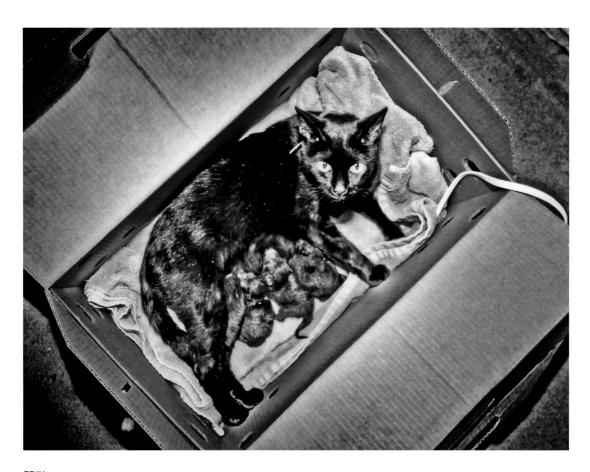

ERIN

The final photograph in this brief series is of mommy with her revived litter in a box with a heating pad, waiting for their intake photos to be taken and be logged into the system.

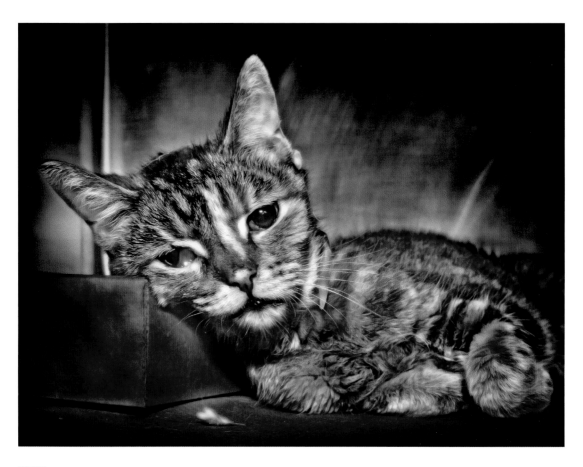

PEPSI

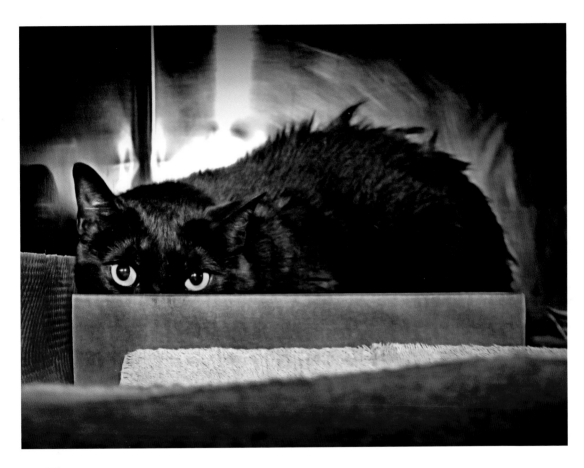

HEAVY D

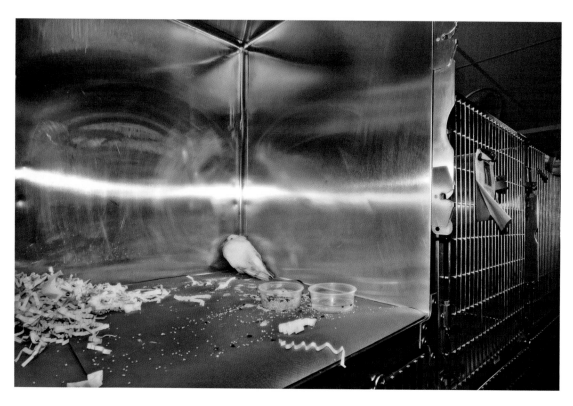

ANGEL

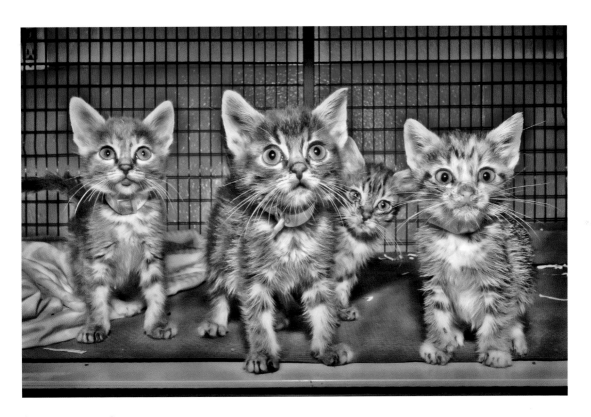

(NAMES UNKNOWN)

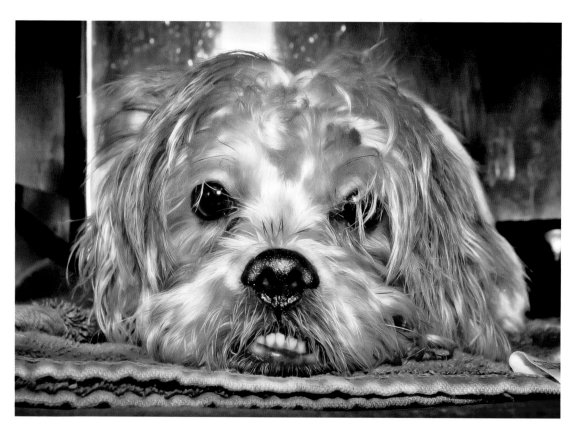

ROSCO

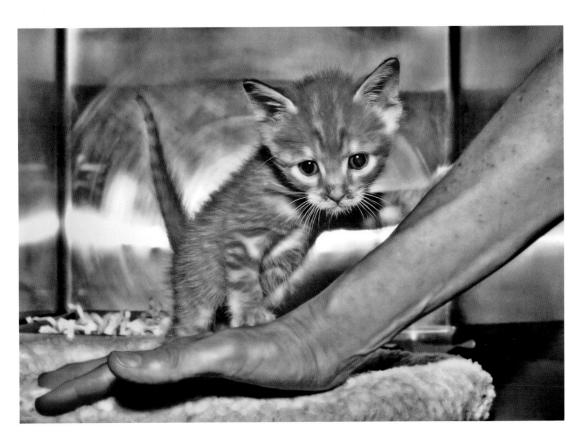

MUFASSA

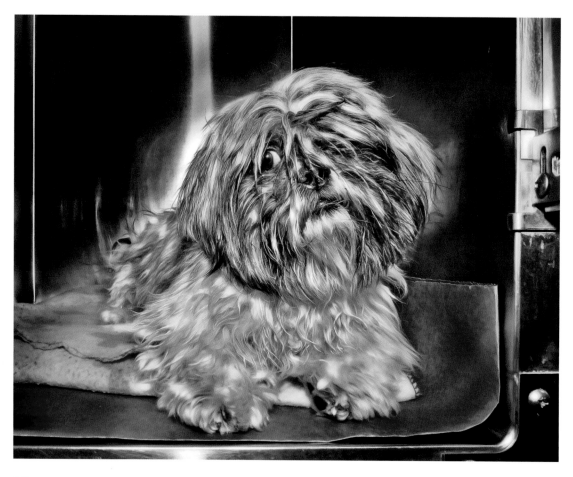

OSCAR

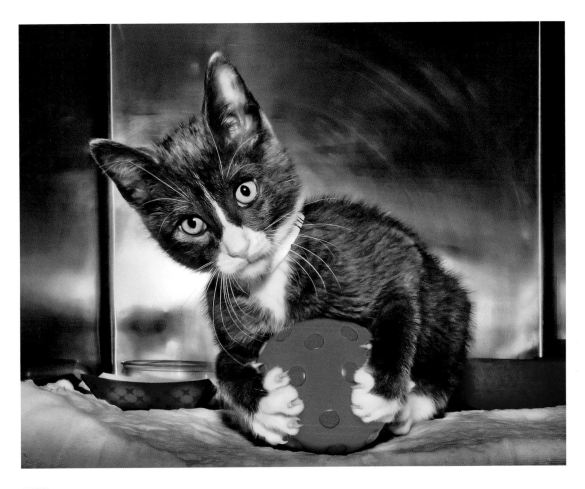

ANGEL

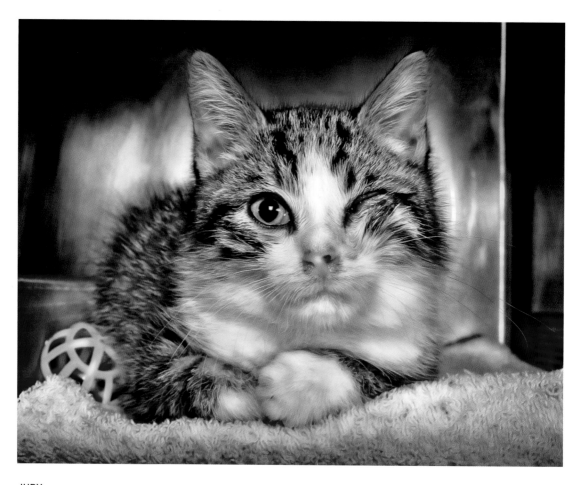

JUDY

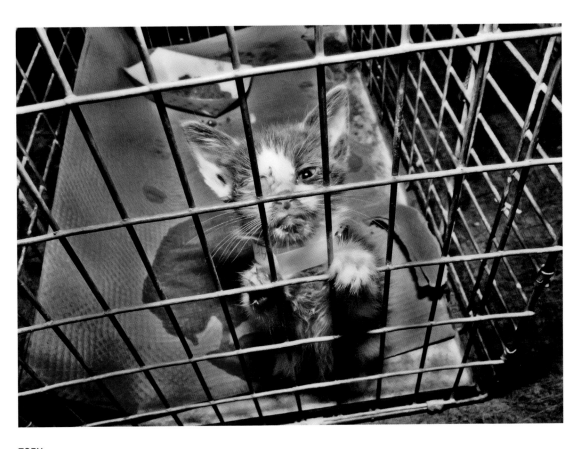

TOBY

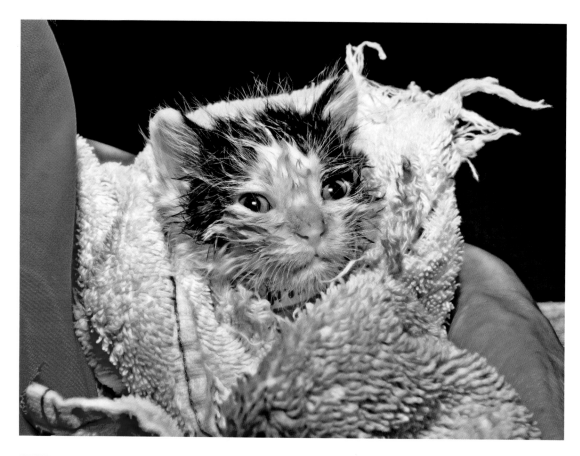

KIMWEL

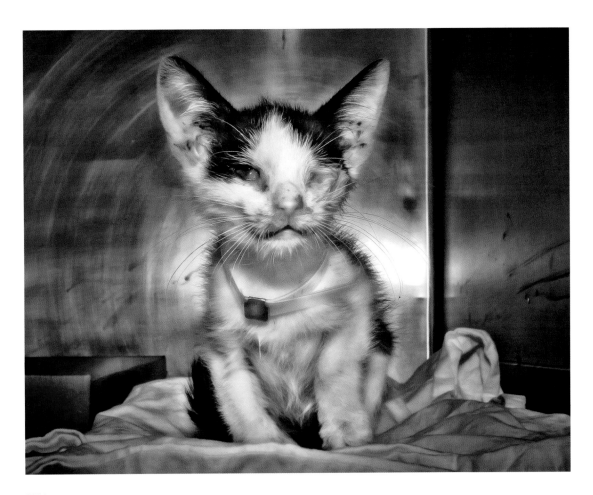

GINA

Gina was saved from a cruel fate, receiving the medical treatment she needed. Only five weeks old, she had a bad case of URI and couldn't eat. But she remained feisty, happy for any attention that distracted her from the solitude of the kennel.

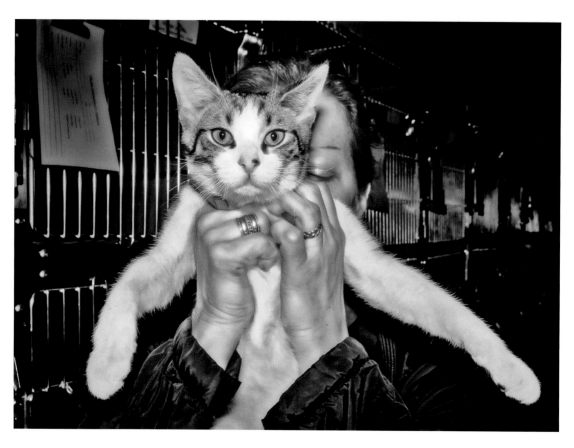

TEDDY

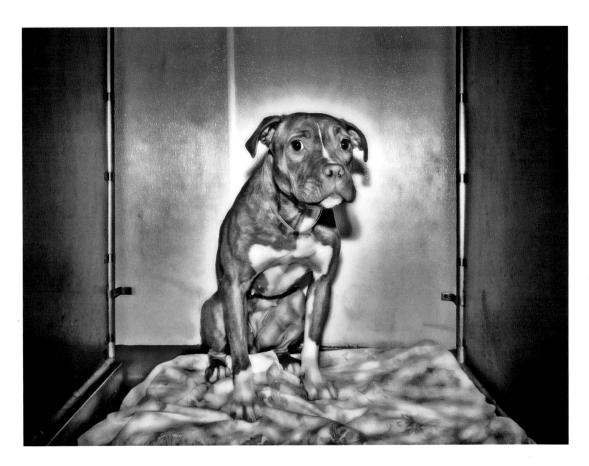

SOPHY

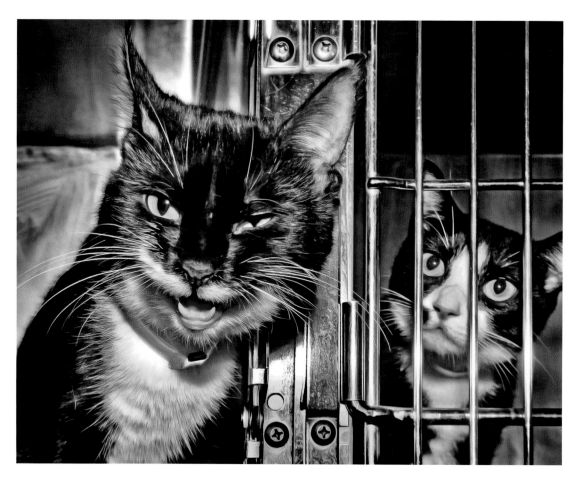

CYRUSS

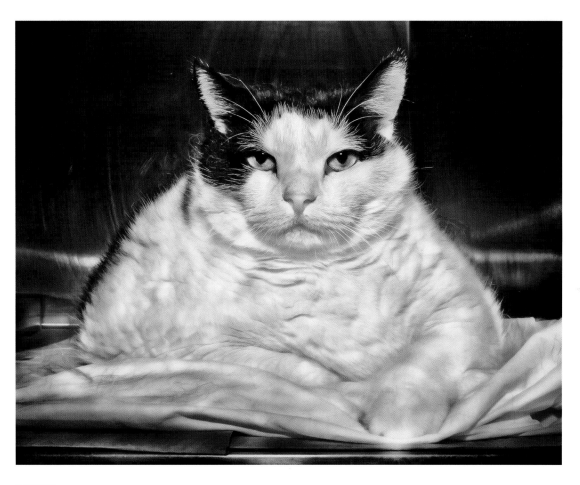

ROCKSY

In looking for a special story to photograph, I came upon one of the saddest sights I'd seen at the shelter. As I hurried past Snowflake's station, something caught my eye but my brain didn't register what I had just seen, not for a second or two at least and then it did. As I backtracked, my heart sank at the sight of this poor soul sitting at the very back of his kennel, face pressed to the cold stainless steel wall as if he were glued to it. He seemed frozen as though he couldn't move. I called to him, tried to get his attention, tried to relax him, tried to comfort him in some small way but to no avail. He simply couldn't respond, not to anything I did, probably not to anything at all. Only his eyes moved, never his body. Glancing at his kennel card I read he was an owner surrender, relinquished because his owner had developed allergies and it was therefore time for Snowflake to go. And so here he found himself, all alone, transfixed in his private abode, isolated and forsaken.

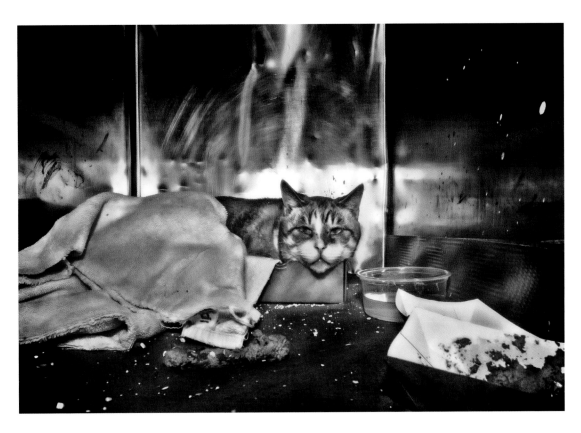

SNOWFLAKE

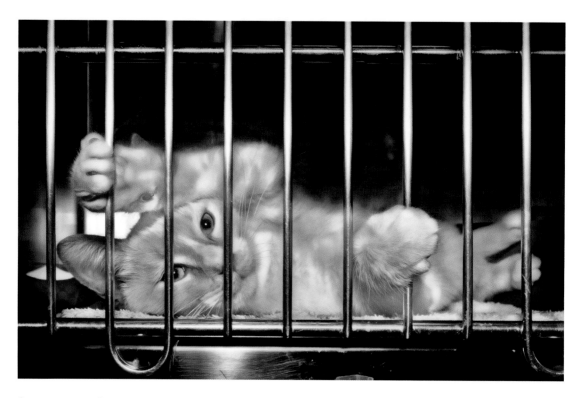

(NAME UNKNOWN)

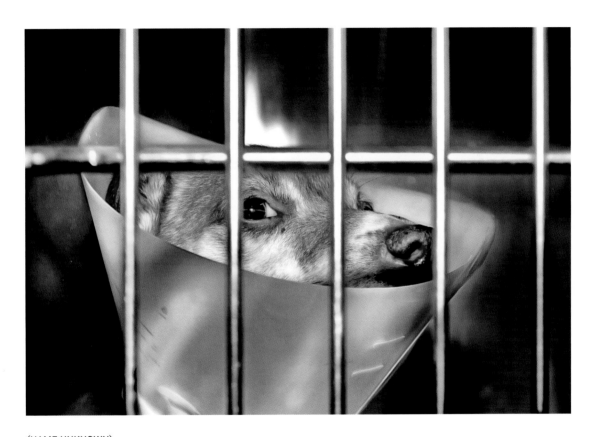

(NAME UNKNOWN)

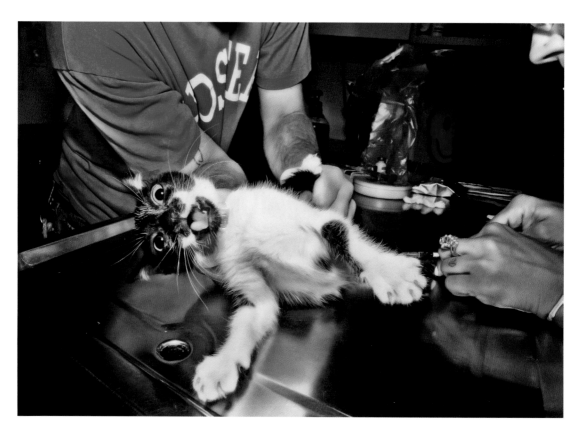

PENELOPE

"I admire the dogs who scream, their spirit is still there. They want to live and they are fighting for it. Ask any volunteer what it's like to try to sleep after a night at the shelter. Impossible is what comes to mind."
—Susan Cava, Manhattan Rescuzilla Animal Rescue President and Founder

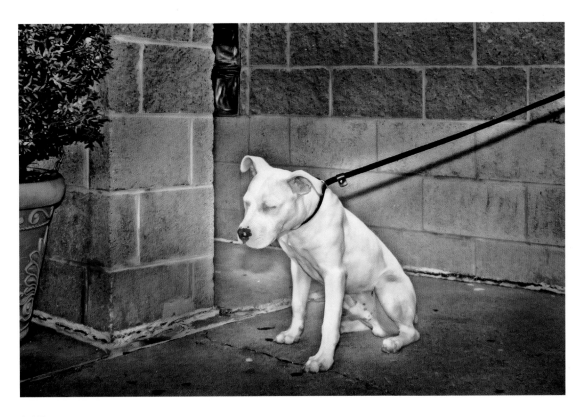

CANO

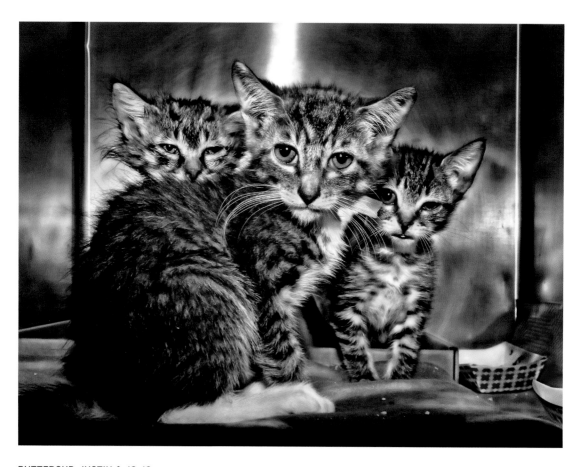

BUTTERCUP, JUSTIN & JO JO

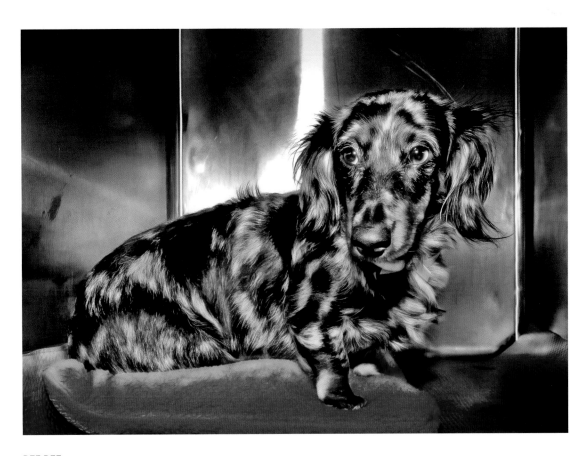

DEE DEE

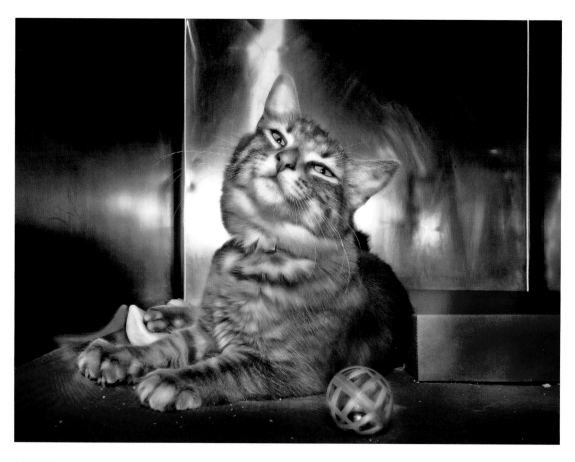

SARAFINA

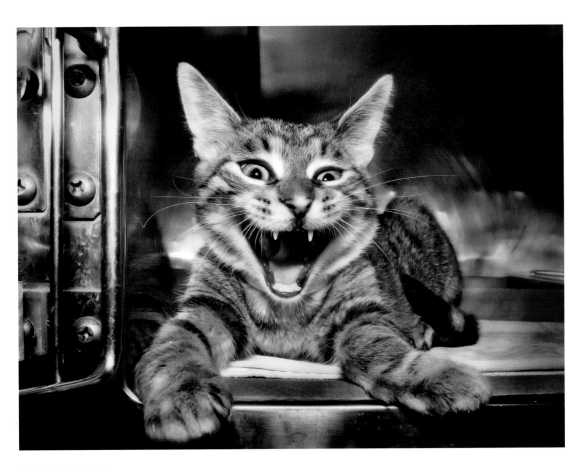

(NAME UNKNOWN)

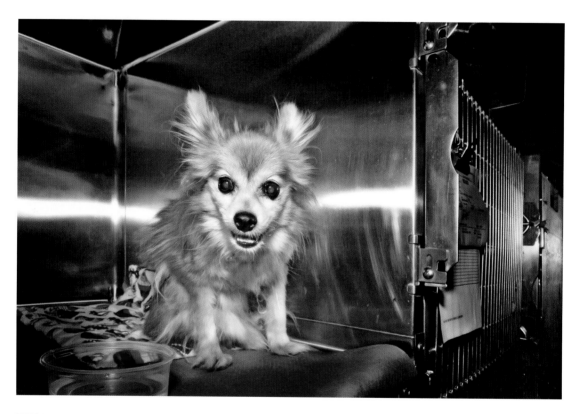

MISSIE

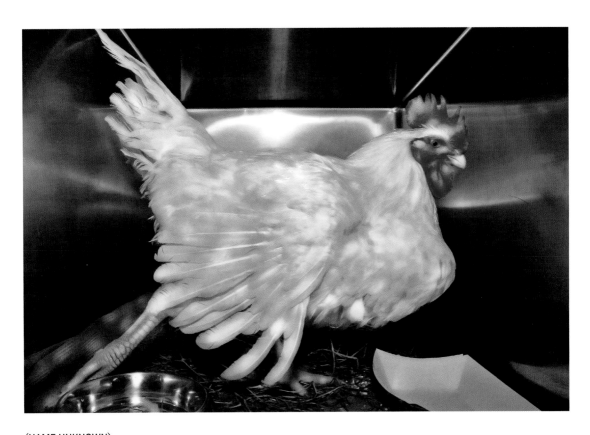

(NAME UNKNOWN)

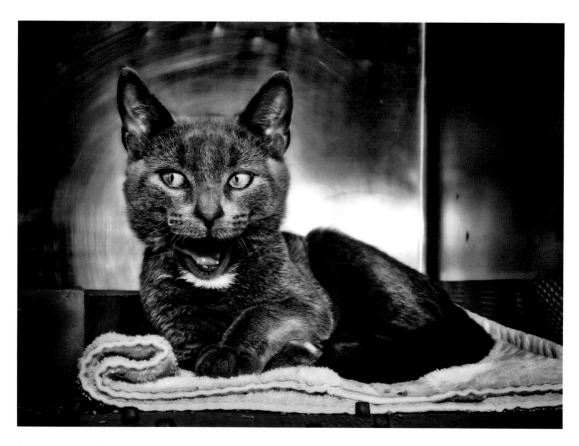

(NAME UNKNOWN)

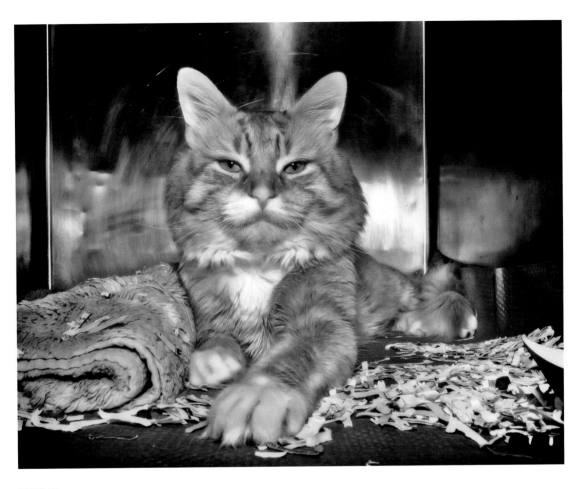

BOMBAY

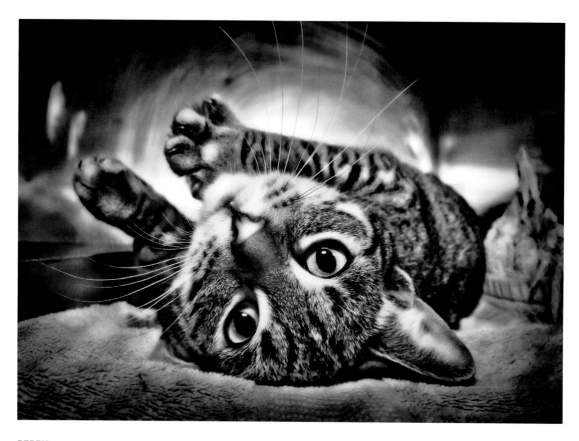

BERRY

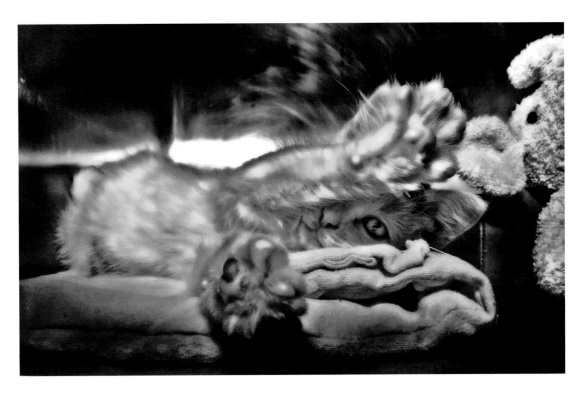

TIFFANY

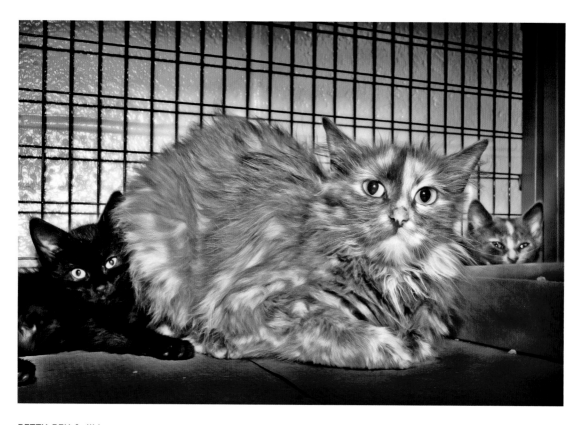

BETTY, BEN & JILL

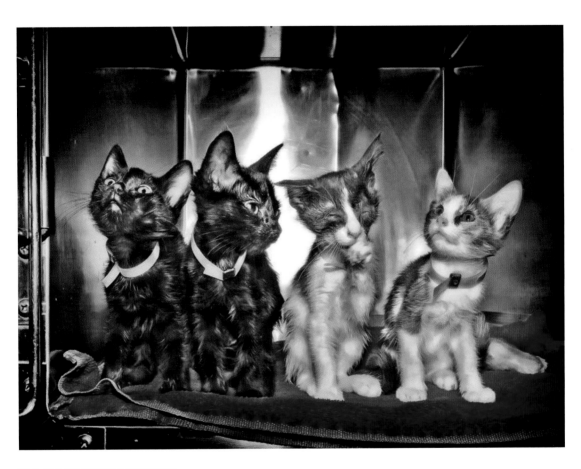

REN, STIMPY, SIMON & THEODORA

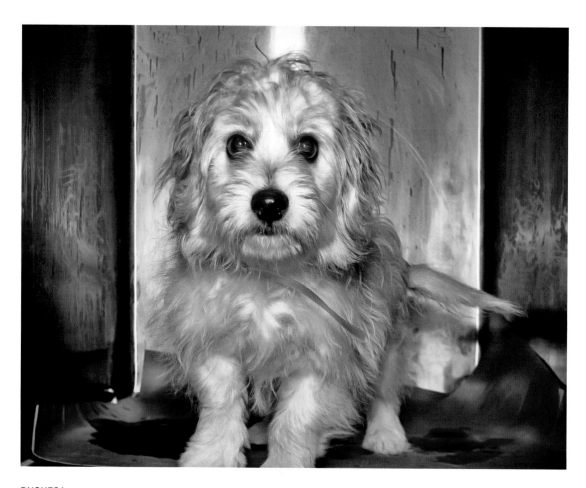

DUQUESA

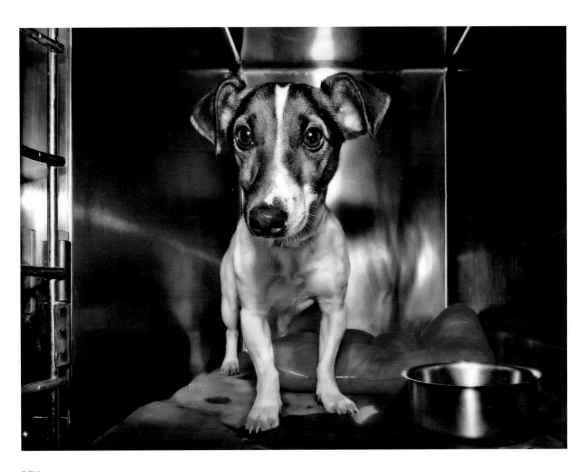

REX

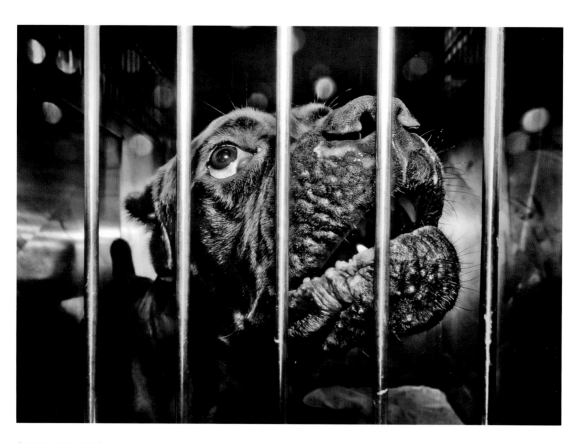

(NAME UNKNOWN)

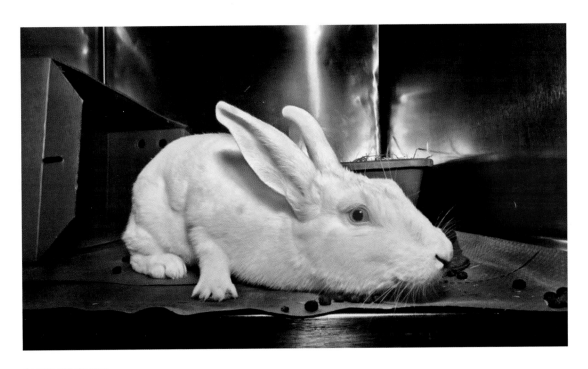

(NAME UNKNOWN)

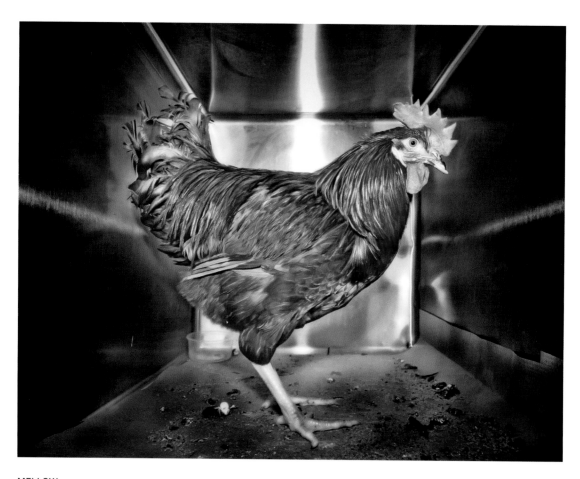

MELLOW

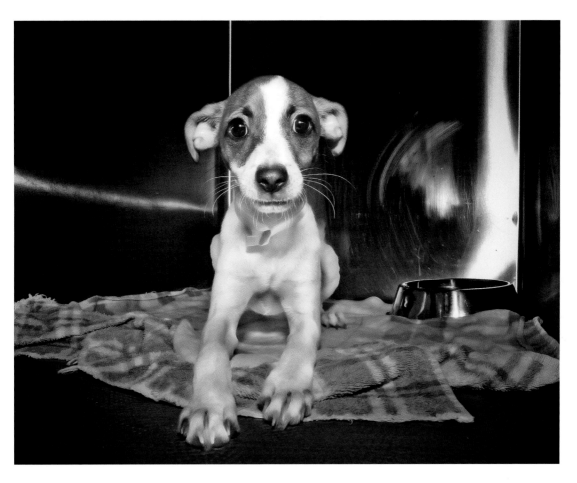

SPOOKY

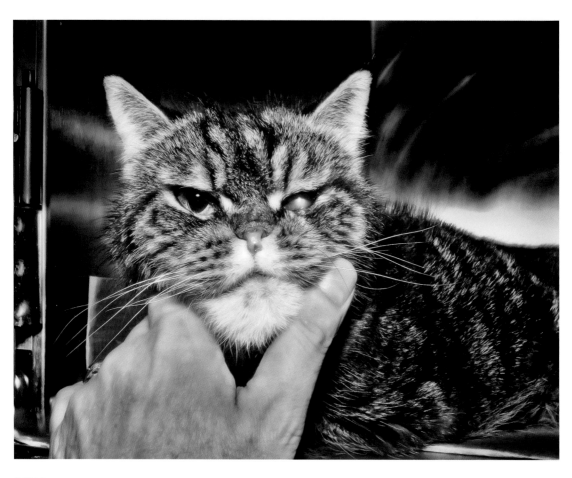

OSCAR

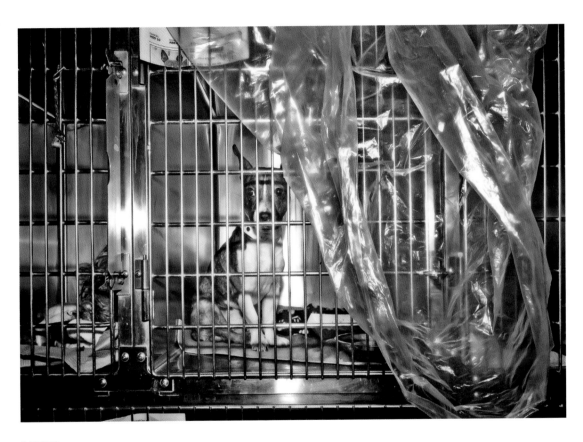

SANCHO

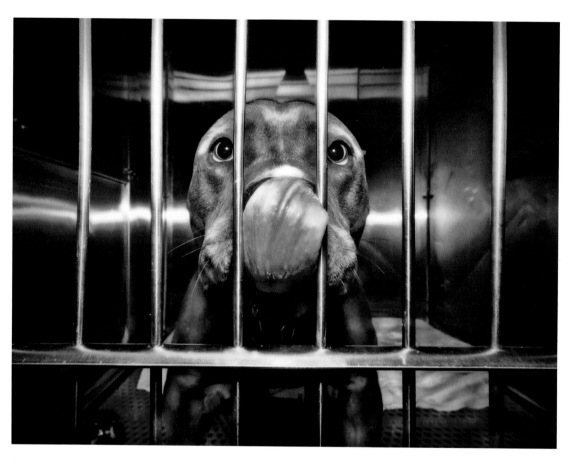

(NAME UNKNOWN)

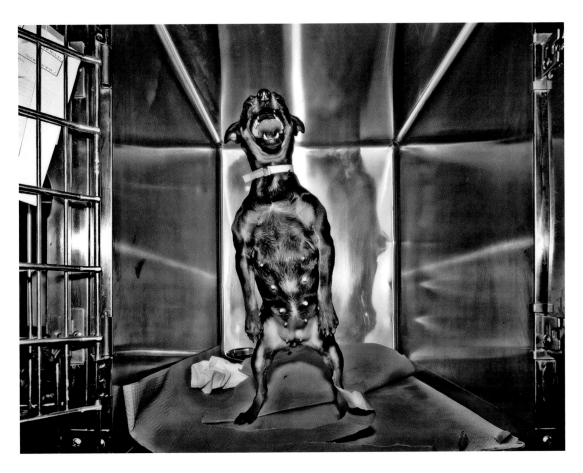

MINNIE

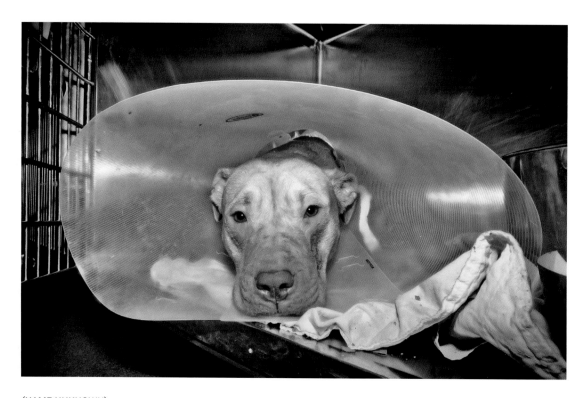

(NAME UNKNOWN)

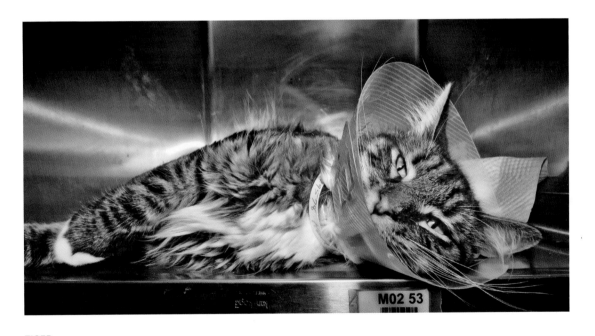

TIGER

WORDS

FROM SHELTER VOLUNTEERS

I COULD NEVER DO WHAT YOU DO

I hear this at least once a week from people who find out that I volunteer at a city animal shelter. For the most part, it is something people say to be polite, and it is usually meant in one of two ways. It's either, "I've always wanted to work with animals but adulthood has made me terrified of commitment and failure" or, "Wow, you must pick up an awful lot of dog poop!"

If you relate more to the second statement, there's really not much I can offer you. If you read the first statement and feel a pang of recognition, though, let me share a secret with you: what most volunteers do is so absurdly fulfilling and satisfying that most of us feel guilty calling it "charity work." In fact, I can't think of anyone, from the most casual volunteer drop-in to the most self-sacrificing rescuer worker, who doesn't feel like they are the ones reaping most of the rewards, despite the exhaustion, the emotional labor, and the helplessness in the face of a society that devalues animals and encourages their exploitation and abuse.

I keep two pictures on my bedroom mirror of the first shelter dogs I ever fell in love with. One dog, Asia, was a beautiful white pit mix with yellow and black facial markings that made her look like a kabuki star. She and I romped in the shelter's backyard on one perfect evening during a snowstorm, no other volunteer in sight, the whole place to ourselves. Lots of dogs love snow, especially fresh snow and we ran around until Asia collapsed on me in exhaustion, tongue hanging, head in my hands, as delighted as any dog I've seen. At that moment in time I knew she thought I was the best, the most fun person she had ever met in her life and I was happier than I could ever remember being.

The other dog on my mirror is named Mary. She was a young black pit, a mother many times over, with had an old limp, possibly from being struck by a car and I was told she was docile but "choosy" with people, which usually means un-socialized or perhaps even abused. I walked her every time I went to the shelter, which sometimes was quite often. We walked slowly; I never pushed her and I never demanded more affection than she was willing to give. Unfortunately, not everyone calmed this wonderful dog and when I'd heard that she bared her teeth at a shelter worker, I knew she had just blown a huge chance at survival, if not her only chance. I took her out that same day and looked deep into her (always) serious little doggie face and wondered at the kind of life she had led and she told me without saying a thing that it had been a long, painful road to arrive at this place. I sobbed tears of anger and helplessness into her dusty black coat, not even caring if staff saw me. Mary waited, never struggling from my embrace and let my tears soak her fur until I was too tired to continue. She was not a perfect dog but she looked straight into the eyes of a bratty, petulant, aimless woman and saw kindness under all of my self-indulgence. How can I ever thank her?

I won't tell you which dog moved on to rescue and which dog didn't. You can probably guess on your own and the answer misses the point. Despite the tears, I have never regretted meeting either of those shining souls. I have never felt like my life was not enriched by knowing an animal—never. This is what it really takes to be a volunteer or paid worker at a "kill" shelter, more than skill or tons of time or an ability to look the other way when animals don't make it. No one I know just "looks the other way" and gets on with it. We all suffer; we all mourn and some days we all fantasize about goofing off and having a glass of wine and a bubble bath instead. But what marks us as fit for this kind of work is the unshakable belief that showing kindness is never a wasted effort. We believe that even heartbreak is a worthy trade-off for the incredible chance that volunteering affords us. For a few measly hours of free time, a volunteer becomes a best friend to an animal who has had every single thing taken from them. Believe me, I don't miss the TV time and neither will you. I leave the shelter each week tired but exhilarated, filled with the love of ten to fifteen of the cutest creatures I've ever seen in my life—at least until next week. My proudest moments as a human being have been at the stinky feet of these incredible animals, my teachers and cherished friends, who understand that the most profound gift you can give another being is to make them feel that they are wonderful. It's never anything less than an honor to spend time with them and every volunteer I know agrees.

So, if you see these stunning pictures from Mark and your heart leaps with that old ache you've always dismissed—if you think you have no time or that you won't be able to withstand the pain or you'll drown in the endless sorrow—please remember the incredible power you hold to make life so much better for these animals, just by being you. Be brave, be beautiful, and take a chance, and perhaps your life will never be the same again.

—A volunteer

I often wonder if people would do the dirty work themselves —that is, kill their animals. Take their leg, take the needle, push it in, erase a life. Of course, everything in our society is sanitized so we don't have to take part in any of the horrors that non-human animals are subjected to, be they animals used for their flesh, their fur, or for "entertainment" or experimentation. And the same goes for our companion animals. It's perfectly acceptable to let someone else do the dirty work of the killing. It's sanitized horror. And the irony is that, for the animals killed at the shelter, it would be an act of mercy on the part of their "guardians" to kill them at home, painlessly (one hopes). At least it would spare the animals the unending stress, fear, and the awareness of death that is the shelter.

—A volunteer

What can I say? When I started volunteering there years ago I had no idea that soon I would be looking at the ugly underbelly of the political forces that control the shelters and the effect that would have on the animals' that have the misfortune of being there. Without going into all the bullshit, suffice it to say that it is, indeed, maddening... All you can do is give as much comfort as you can to the animals that are there, and try and get good homes for them. The ones that don't make it you try not to think about. Every time you hear a cat sneeze, or a dog cough, you have the sinking feeling that if they go to the sick ward they will not be coming back to the adoption ward. It's usually the first step to euthanasia. The volunteers that you find occasionally weeping in the halls you have to comfort, and tell them that they cannot give in to those feelings or they won't be any help to the animals. Thank God that the animals live in the present and don't know that if they don't get adopted or taken to a rescue facility, they will be put to death. That is probably the only thing that keeps me coming back... that and the people that come in and adopt an animal into a good home.

—A volunteer

First, your pet will be taken from its kennel on a leash. They always look like they think they are going for a walk—happy, wagging their tails—until they get to "The Room." Then every one of them freaks out and puts on the brakes. They must smell death; it's strange, but it happens with every one of them. Your dog or cat will be restrained, held down by one or two vet techs. Then a euthanasia tech or a vet will start the process, finding a vein in the front leg and injecting a lethal dose of the "pink stuff." Sometimes the pet really panics and the needle tears out of the leg. When this happens there is lots of blood and deafening yelps and screams. They don't all just "go to sleep," sometimes they spasm for a while, gasp for air, and defecate.

When it all ends, your pet's corpse will be stacked like firewood in a large freezer in the back with all of the other animals that were killed, waiting to be picked up like garbage. What happens next? Cremated? Taken to the dump? Rendered into pet food? You'll never know and it probably won't even cross your mind. It was just an animal and you can always buy another one, right?

I hope that those of you that have read this are bawling your eyes out and can't get the pictures out of your head I deal with every day on the way home from work.

I hate my job, I hate that it exists and I hate that it will always be there unless you people make some changes and realize that the lives you are affecting go much farther than the pets you dump at a shelter.

—Excerpt from a shelter manager letter, posted on Craigslist, December 16, 2008.

"If every animal shelter in the United States embraced the No Kill philosophy and the programs and services that make it possible, we would save nearly four million dogs and cats who are scheduled to die in shelters this year, and the year after that. It is not an impossible dream."

Proceeds from this book will be donated to:
No Kill Advocacy Center
6114 La Salle Ave. #837
Oakland CA 94611
510.530.5124

For more information: www.nokilladvocacycenter.org